Christmas 2011

Cameron
 I hope This book will
interest you in Geology And
make you appreciative of
our Roman Heritage

ASHEN
SKY love
 Howard

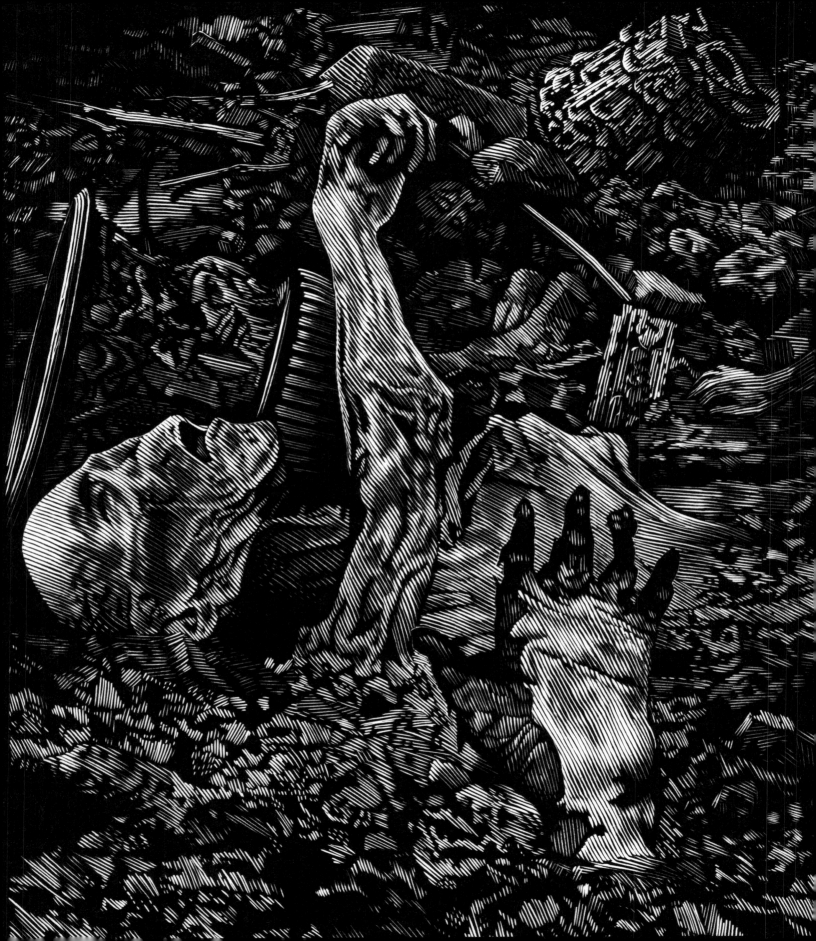

ASHEN SKY

The Letters of Pliny the Younger
on the Eruption of Vesuvius

Illustrated by Barry Moser

Written and Translated by
Benedicte Gilman

The J. Paul Getty Museum · Los Angeles

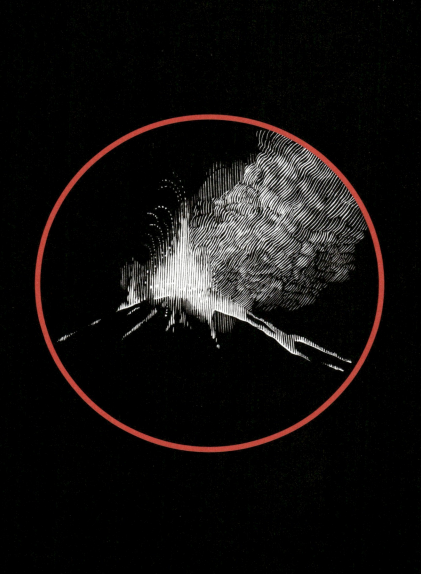

Contents

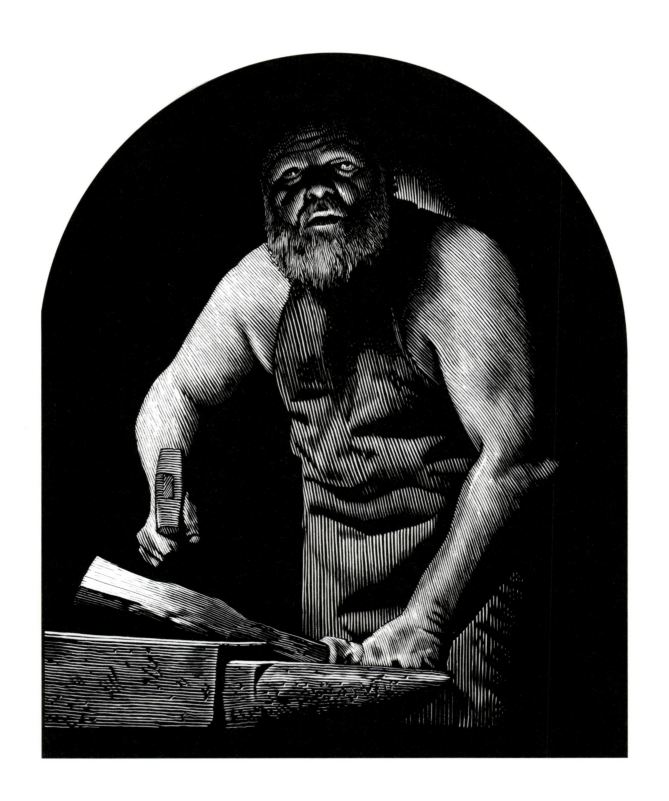

VULCAN, GOD OF THE FORGE

Introduction

One of the most famous natural disasters in history was the eruption on August 24, A.D. 79, of Mount Vesuvius, near Naples, in the Campania region of Italy. The explosive event started on a day that, ominously, was the feast day of Vulcan, god of the forge, and it lasted for two days. By the time it was over, earthquakes, a series of hot-air surges and pyroclastic flows, and large quantities of lapilli—small pieces of pumice—had killed hundreds or perhaps thousands of people and buried towns, villas, and the surrounding countryside. The best-known losses were the two towns of Pompeii and Herculaneum.

While Herculaneum was completely buried, Pompeii was covered by a thinner and less dense layer of pyroclastic material and lapilli. The tops of the highest buildings remained above the volcanic deposits, making it at least theoretically possible to dig down through the lapilli and ash to extract valuables from concealed buildings. A number of holes in the walls of houses in Pompeii testify to the fact that such explorations were indeed carried out in antiquity, either by former owners of the houses or by robbers.

In Rome, Titus, who had become emperor only two months earlier, ordered that the property of those who died without surviving heirs should be used to help finance relief work—rather than routed to the imperial coffers, as would normally have happened. Titus contributed these funds to the rebuilding of towns damaged in the cataclysm.

The memory of the "dread mountain's fiery storm" (Statius *Silvae* 3.5.72) eventually receded, and new settlements sprang up on the slopes of the volcano and in the surrounding countryside. Today the area around the volcano is densely populated, even though the mountain still poses a risk. Over the past two thousand years, the volcano has been quite active during several periods. A major eruption in 1631 pushed the nearby shoreline further into the Mediterranean Sea. In 1787 the German poet Goethe was enchanted by the spectacle of the nighttime eruption of Vesuvius.

> Night was already falling, but candles had not yet been brought in. . . . [She] pushed open the window shutters, and I saw a sight such as one gets to see only once in a lifetime. If she did it on purpose in order to surprise me, she certainly succeeded eminently. From an upstairs window we had Vesuvius right in front of us; lava flowed down the mountain, and, with the sun long since set, the flames glowed clearly and their smoke took on a golden aspect; the mountain rumbled violently, and above it hung an enormous cloud of steam, whose varying shape was split as if by lightning and illuminated with each new upsurge from the volcano. From the summit down toward the sea was a streak of flames and glowing steam; resting in magical peace, sea and land, rock and vegetation were clearly visible in the fading evening light. To take in all this at one glance and see the full moon rising behind the ridge of the mountain as the completion of the most wonderful picture certainly had to cause some astonishment.
>
> (Goethe, *Italian Journey*, June 2, 1787)

The accounts of one eyewitness to the eruption of August A.D. 79 have kept it very much alive in literature. The seventeen-year-old Gaius Plinius Caecilius Secundus (Pliny the Younger) was living with his mother in the house of her brother Gaius Plinius Secundus (Pliny the Elder) at Misenum, 32 kilometers across the bay from Vesuvius. Some twenty five years later, at the request of his friend the historian Tacitus, Pliny the Younger wrote two letters describing the events surrounding the eruption and the circumstances of his uncle's death during the disaster.

The Eruption of Mount Vesuvius

In A.D. 79 memory was long lost of another major eruption of Mount Vesuvius, the Avellino eruption, which around 1700 B.C. devastated an even larger area of what was then Bronze Age Italy than did the eruption in A.D. 79. The Romans knew that the mountain was a volcano, but they thought it was extinct. The region's mild climate and fertile soil had made it a favorite area of relaxation for wealthy Romans, whose opulent country estates dotted the landscape. Southeast of the volcano lay Pompeii, a bustling but unremarkable commercial town with a population estimated to be around twelve thousand. West of Vesuvius, on the coast above the Bay of Naples and demanding glorious views of the entire bay, was Herculaneum, a wealthy resort town with six thousand inhabitants.

At midday on August 24 the mountain exploded. A convective column shaped like a Mediterranean pine rose above the volcano, eventually reaching a height of some 30 kilometers, making it visible for many miles around. In this initial stage of the eruption (stage A)—called the Plinian phase, in honor of Pliny the Younger's accurate description of it—ash and various sizes of rocks and pumice stones were ejected along with hot gases and water vapor at a rate of 1,200 kilometers an hour. High-altitude winds pushed the top of the column south and southeast from the volcano, spreading it over thousands of square kilometers. Within an hour or two, lapilli and ash began to rain down on Pompeii and the area southeast of the volcano, while Herculaneum to the west avoided most of this deposition. The lapilli accumulated in Pompeii at a rate of about 15 centimeters an hour.

9

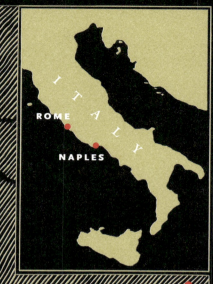

CAMPANIA

AVELLINO

NAPLES

MISENUM

HERCULANEUM

Mount Vesuvius

Bay of Naples

POMPEII

STABIAE

SORRENTO

Around midnight on August 24, the eruption changed to stage B. The ash column collapsed onto the volcano, which generated very hot, dust-laden clouds (so-called *nuées ardentes*, burning clouds) that swept down the steep mountain at speeds of up to 300 kilometers an hour.

At the bottom of a *nuée ardente* is a dense concentration of gas and particles called a pyroclastic flow. The upper part of the cloud consists of a highly turbulent mixture of gas and particles called a pyroclastic surge. Because of the speed of the cloud, it will pick up rocks and large objects in its way and hurl them along as lethal projectiles. The blistering air also chars everything combustible in its path. The hot, dry rock fragments (ranging from minuscule particles to boulders) and the scorching surges (between from 100°C and 500°C) traveling at very high speed knocked down, shattered, carried off, and buried many objects in their way. Anybody in the path of the first *nuée ardente* when it traveled down the slopes of Vesuvius would have been killed instantly by the heat or asphyxiated by the lack of oxygen in the cloud. In Herculaneum death was so sudden—it happened in a fraction of a second—that people there did not even have time to assume self-protective poses or agonized contortions, as we know them from victims in Pompeii.

The first and smallest *nuée ardente* reached Herculaneum and a large area west of the volcano, but it mostly spared the area to the south and southeast, including Pompeii. During the next seven hours, there were a total of six alternating episodes of stages A and B of the eruption. Each time a *nuée ardente* burst down the mountain, the pyroclastic flow expanded further. Around 6:30 A.M. on August 25, the fourth surge and flow reached Pompeii and buried it. The sixth and largest surge probably corresponds

to the "terrifying pitch-black cloud" Pliny saw spreading over the Bay of Naples around 7 A.M. on August 25 (letter 6.20.9). Although Pliny's account of the eruption ends there, the eruption continued, as evidenced by deposits in the area. There may have been as many as twenty additional surges and lapilli deposits, perhaps continuing for days or weeks.

By the time the eruption ended, some 300 square kilometers around Vesuvius had been totally devastated. Herculaneum was buried so thoroughly that its location was soon forgotten. Subsequent eruptions of Vesuvius—most notably the explosive one in 1631—ultimately covered the town with up to 30 meters of pyroclastic material. This flow cooled and dried to a rock-hard layer of tuff that kept the site of Herculaneum hidden until its chance rediscovery in the early eighteenth century.

Eruptions as powerful as that of Vesuvius in A.D. 79 occur on earth only once a millennium. Although the volcano is still active and Campania is still subject to devastating earthquakes, nothing close to the cataclysm of A.D. 79 has been seen from Vesuvius in the last two millennia. The mountain's most recent major activity took place in the spring of 1944. It started on January 8 and continued as a series of eruptions over the next months, reaching its climax in March before coming to an end late that month. Two villages, San Sebastiano and San Masso, were destroyed by lava flow on March 21 that year. The volcano has had no serious eruptions since then.

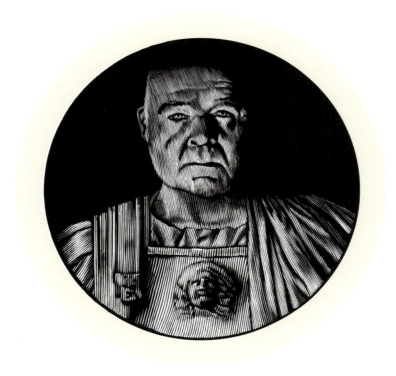

Pliny the Elder

CAIUS PLINIUS SECUNDUS was born into the landed aristocracy of Como in northern Italy about A.D. 23/24. His public career included several posts as procurator (governor), notably of eastern Spain. He was a member of the councils of Emperors Vespasian and Titus. In the seventies, he had accepted command of the west Italian fleet at Misenum, on the north side of the Bay of Naples.

Throughout his life Pliny was a prolific writer. The time he spent on an equestrian command in Germany led to a twenty-volume now-lost work, *Bella Germaniae*, on the Roman wars against the Germans. These books

later became the foundation for Tacitus's writing on the Germans and their customs. Other writings by Pliny include a book on the use of the throwing-spear by cavalrymen, a collection of phrases for use by orators, and a history of the later Julio-Claudian period.

Pliny's best-known work by far, however, is his thirty-seven-book *Natural History*. This encyclopedic work—based on two thousand books, as the author claims in his preface—is our source for much important knowledge of antiquity. So all-encompassing are these books that they give us a summation of the state of knowledge in the first century A.D. Pliny dealt mainly with technical matters such as agriculture, metallurgy, gold mining, medicine, geology, and the canons of famous ancient artists. He did not have much to say about economics, religion, or philosophy, and he was not given to philosophizing. He attempted to be comprehensive in the areas he chose to write about, even if the accuracy of much of his information is not beyond doubt.

Pliny abhorred wasting time, keeping about him men who would read aloud to him at every waking moment, even when he was bathing or taking walks about his estates. His keenly inquisitive mind never missed an opportunity to gather new knowledge or to investigate a natural phenomenon. This scientific curiosity apparently cost him his life, for he died on August 25, A.D. 79, while attempting to investigate the eruption of Mount Vesuvius.

Tacitus

PUBLIUS (OR GAIUS) CORNELIUS TACITUS was one of the greatest Roman historians. He was born, probably in the north of Italy or south of France, about A.D. 55/56. Based on the aristocratic biases evident in his writings, he seems to have come from a family of means and position. His public career included being praetor (a magistrate associated with the courts in Rome) in A.D. 88, followed by a legateship and then a consulship in A.D. 97. In A.D. III he was appointed governor of western Anatolia under Emperor Trajan. He died after A.D. 118.

Tacitus was a friend and teacher of Pliny the Younger, and the two men were associated with each other in legal proceedings. Thus, in A.D. 100 they successfully impeached the oppressive Roman governor Marius Priscus on behalf of their African clients.

In addition to his legal and public endeavors, Tacitus was a prolific writer. His minor works include a biography of his father-in-law, Agricola, who had served as governor of Britain; a treatise on the German tribes (both in A.D. 98); and a *Dialogue on Orators* on the state of oratory in Rome. He also wrote twelve to fourteen books of *Histories,* covering the years A.D. 69 to 96, and eighteen books of *Annals* (A.D. 116), covering the years A.D. 14 to 68, of which only Books 1 through 4, most of 6, and 11 through 16 have survived.

To gather material for his *Histories,* Tacitus asked his friend Pliny the Younger to write a description of his uncle's death during the eruption of Vesuvius. Pliny complied, writing not one but two letters. Only the first four and a half books of Tacitus's *Histories* survive, ending in A.D. 70, so the use Tacitus may have made of Pliny's letters is not preserved as part of his work.

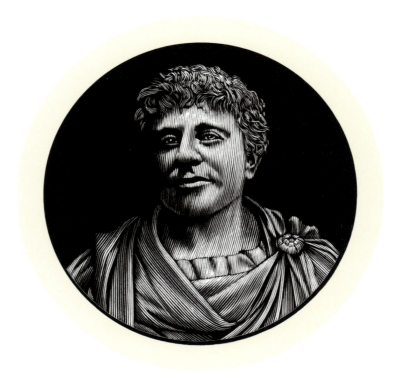

Pliny the Younger

GAIUS PLINIUS CAECILIUS SECUNDUS was born in Como, in northern Italy, about A.D. 61. His father, Lucius Caecilius, was a wealthy local land-owner, and his mother was from the aristocratic Plinius family in Como. After his father died when Pliny was eight, he was brought up in Como and Rome in the houses of his maternal uncle, Pliny the Elder. The uncle probably also adopted him, as indicated by the fact that Pliny the Younger took over his uncle's name. Through inheritance and marriages, Pliny came to own country estates in Tuscany and Campania as well as land around Como.

Pliny received the usual education for a young man from an aristocratic family: He studied rhetoric, for the ability to speak in public was essential for a career. The famous orator Nicetes of Smyrna taught him Greek rhetoric, and Quintilian, one of the most influential authors of his day, did the same for Latin rhetoric. At the age of only eighteen, Pliny drew attention to himself when he used his remarkable rhetorical skill to win a difficult court case.

With the help of friends and family, he was launched into a public career. After local service at courts in Como, he became an administrator with a Syrian legion around A.D. 81. This was followed by a quaestorship, which gave him automatic admission to the senate in Rome. Next he worked as a tribune, then a praetor (perhaps in A.D. 93), a consul, and an augur. Finally, he was appointed by Emperor Trajan as legate of Bithynia-Pontus (northern Asia Minor), where he supervised the finances of the province. He probably died there, around A.D. 118.

Pliny wrote letters prolifically: Some 248 of them have survived until our time. The letters are often very entertaining. Pliny tells a ghost story, conducts a guided tour of several of his houses, gives accounts of lawsuits, and describes the friendship between a boy and a dolphin. Many are correspondences with friends—eleven of the letters are addressed to Tacitus—some deal with business affairs or domestic matters, and a few are letters of recommendation. And then there is a large group of "letters" that are better described as formal compositions on political and social events as well as natural phenomena. Each of these texts is usually quite brief and limited to one subject, often in the form of an essay. Pliny's training in rhetoric is evident in his letters. He crafted his language very carefully, using simple

vocabulary and paying close attention to rhythm and tone. While clearly influenced by contemporary styles of oratory, his letters are first and foremost literary compositions, which seem to be intended for publication. In fact, Pliny edited and published nine books of letters in his lifetime. After his death, his friends published a tenth book of his letters, containing his official correspondence with Emperor Trajan during his time as legate in Bithynia-Pontus.

Sometimes, a friend would propose a topic for a letter. This was the case with Pliny's two letters on the eruption of Vesuvius, probably written in late A.D. 107 or during the first half of 108. For his *Histories,* Tacitus had asked Pliny to write about the death of his uncle. Despite the many intervening years, Pliny's memory of the eruption was still very clear, and his account is detailed and objective. He seems to have learned from his uncle how to make careful observations and to draw only substantiated conclusions. In fact, Pliny's description of the course of the eruption can be traced almost hour by hour in the volcanic deposits.

The Survival of Pliny's Letters on the Eruption of Mount Vesuvius

Pliny edited and published nine volumes of private letters during his lifetime; a collection of his official correspondence (containing his famous letter to the emperor Trajan about the new sect of Christianity, along with Trajan's reply) was added after Pliny's death as a tenth book, perhaps in the fourth century, when there was a revival of interest in Pliny and other Latin authors of the first century A.D. The letters were repeatedly copied and some were preserved in manuscripts in various European monasteries.

Not all of the manuscripts that have survived contain Pliny's two letters on the eruption of Vesuvius and the death of his uncle. One of the best sources for these letters is codex *Laurentianus Mediceus* 47.36 in Florence, known as version *M*, which dates from the last quarter of the tenth century. This manuscript, written in the script of Fulda (in Germany), was furtively removed from the Benedictine abbey of Corvey in Westphalia, northern Germany, and brought to Florence in 1508. Other manuscripts derive from two archetypes (called *g* and *q*), both of which were lost after copies were made of them.

Pliny's two letters on the events on the events of August A.D. 79 are referred to as 6.16 and 6.20, meaning that they both come from volume six of his published correspondence, where they are, respectively, the sixteenth and the twentieth letters. The numbers in brackets in the letter texts are the traditional numeration of the "sentences."

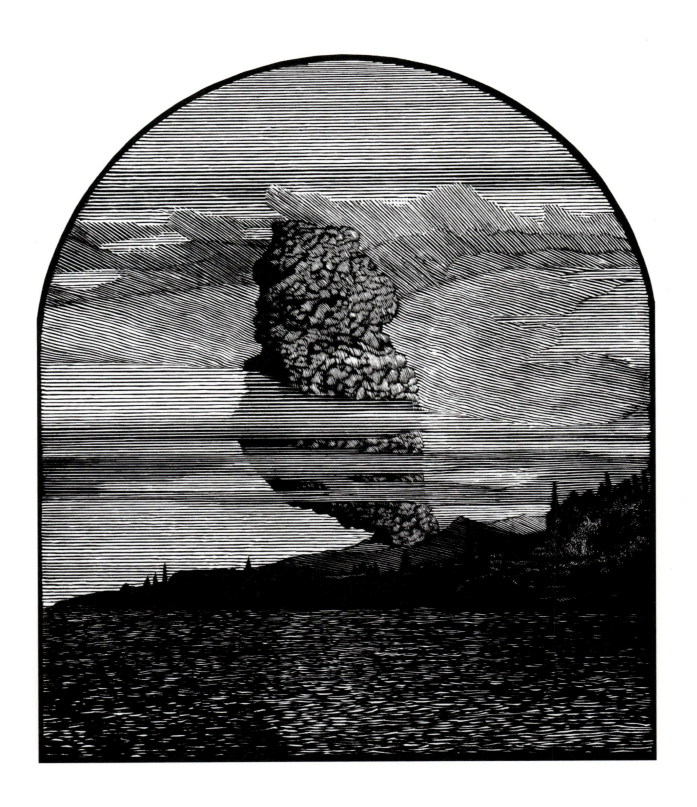

A CLOUD OF UNUSUAL SIZE AND FORM

LETTER 6.16

Pliny greets his friend Tacitus.

Thank you for asking me to write to you about my uncle's death, so that you can give a more accurate account of it in your history. I know that his death will achieve immortal fame if it is published by you. [2] For although he perished in a disaster that destroyed the most beautiful areas of the world, in a misfortune shared by people and cities, and although he himself wrote many works of lasting value, still your writings will do much to preserve his name for eternity. [3] I think they are lucky whom the gods have given the gift of either doing something worth writing about or writing something worth reading, but those who have done both are the most blessed of all. Such a man was my uncle, because of his own books and because of yours. Therefore I am more than willing, in fact, I insist on doing what you ask of me.

[4] My uncle was at Misenum, in command of the fleet. On 24 August in the early afternoon, my mother pointed out to him the appearance of a cloud of unusual size and form. [5] He had been enjoying the sun, had taken a cold bath, had partaken of a light lunch, and was now busy with his books. He called for his sandals and climbed up to a place from which he could best view the unusual event. A cloud was rising from a mountain—which mountain was unclear to those who looked at it from a distance (it was later learned that it was Vesuvius). The shape of the cloud

can best be described as resembling an umbrella pine, since [6] it rose up high just like a tree-trunk and then branched out in different directions, as I believe, because it was carried up by the first emission, and then, as that grew weaker or was overcome with its own weight, the cloud began to spread out and disappear. Sometimes the cloud was white, sometimes dirty and speckled, depending on how much dirt and ash it carried with it. To a man of my uncle's great intellect, it was important to take a firsthand look for himself. [7] He gave orders that a fast ship be prepared and offered that I could come with him if I wished. I replied that I should prefer to continue with my studies, for he himself had happened to give me something to write.

[8] As he was leaving the house, he received a note from Rectina, the wife of Tascius, who was terrified by the looming danger (for her villa was very close to the volcano and there was no escape except by boat). She pleaded with him to rescue her from so much danger. [9] He changed his plans, and what had begun with an inquisitive spirit ended in heroism. He ordered the launching of the warships and embarked himself, intent on bringing help not just to Rectina but to many more people (for the beautiful stretch of coast was densely populated). [10] He hurried to the place others were fleeing from, setting his course straight for the dangerous area, so utterly fearless that he dictated each movement and change in shape of the disaster as he observed them.

[11] By now ash was falling on the ships, hotter and thicker the closer they approached; then pumice and blackened stones, burnt and fractured by the fire. Suddenly the water became shallow and the shore was blocked by the collapse of the mountain. My uncle hesitated a bit, wondering whether to turn back, but then said to the helmsman who warned him do to just that,

22

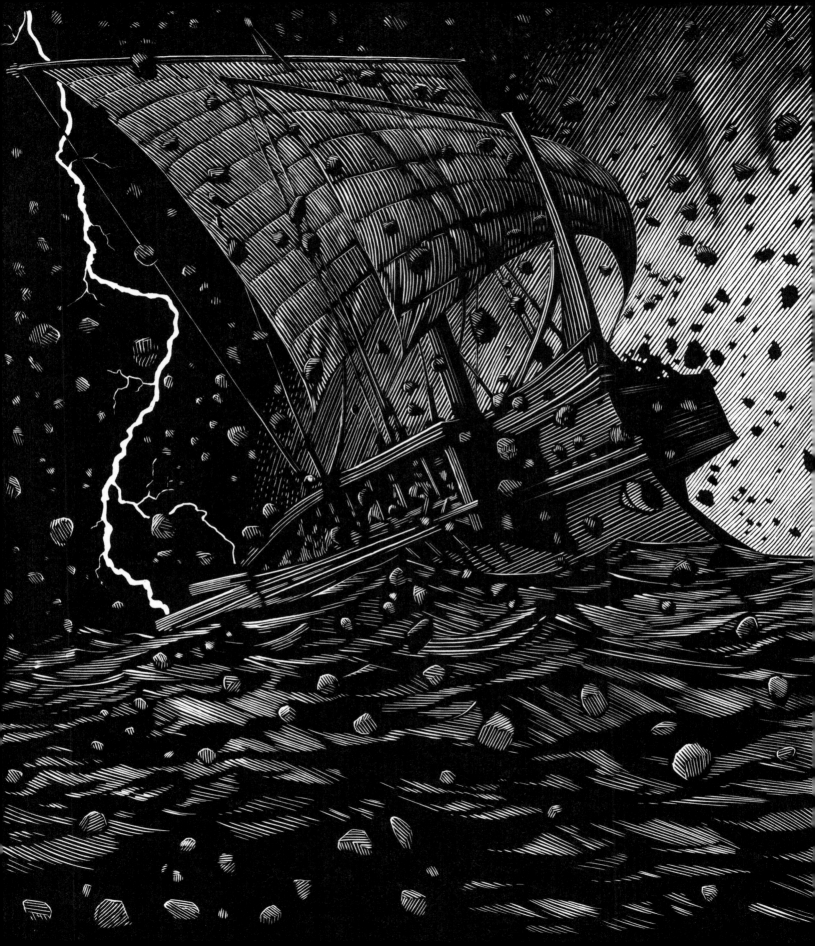

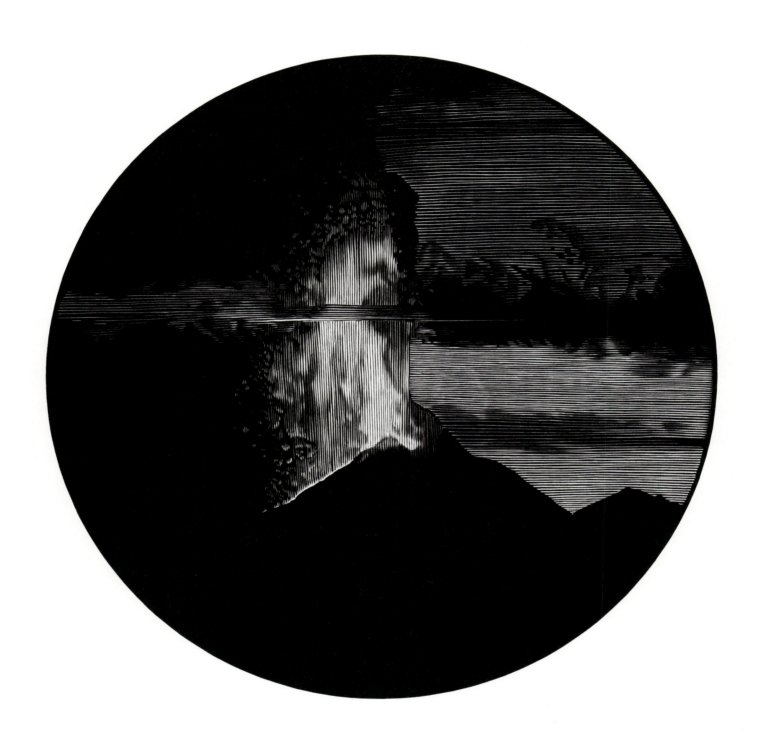

BROAD BANDS OF FLAMES

"'Fortune favors the brave': head for [my friend] Pomponianus." [13] Pomponianus was at Stabiae, separated by the middle of the bay (for the shore gradually curves around where the sea pours into the bay). There, although Pomponianus was not yet in imminent danger, it was clear the threat was getting closer. He had therefore brought his belongings onto a ship, determined to flee if the adverse wind subsided. This strong tailwind was, of course, what carried my uncle ashore; he embraced his anxious friend and consoled and encouraged him. In order to alleviate his friend's fear by demonstrating his own composure, my uncle ordered that he be taken to the baths. After he had washed, he lay down and had dinner; either he was cheerful or—equally admirable—he gave the impression of being cheerful.

[13] Meanwhile, from many places on Mount Vesuvius, broad bands of flames and soaring fires again began to blaze, their sparkling brightness increased by the dark of night. To allay the fears of his companions, my uncle repeatedly said that these were bonfires left untended by country folk in their panic, and uninhabited villas that were burning because they had been abandoned. Then he went to bed and actually fell asleep, for his breathing, which because of his ample body was rather heavy and loud, was heard by those who were keeping watch outside his door. [14] But the courtyard that his bedroom gave onto was now filling up with ashes mixed with pumice, so if he stayed in the bedroom any longer, he would not be able to get out. When he was woken up, he went out and joined Pomponianus and the others who had stayed awake all night. [15] They discussed whether to remain indoors or wander in the open, for the building was rocking with frequent and severe tremors and seemed to be swaying back and forth as if shaken from its foundation. [16] Out in the open, on the other hand, there was the

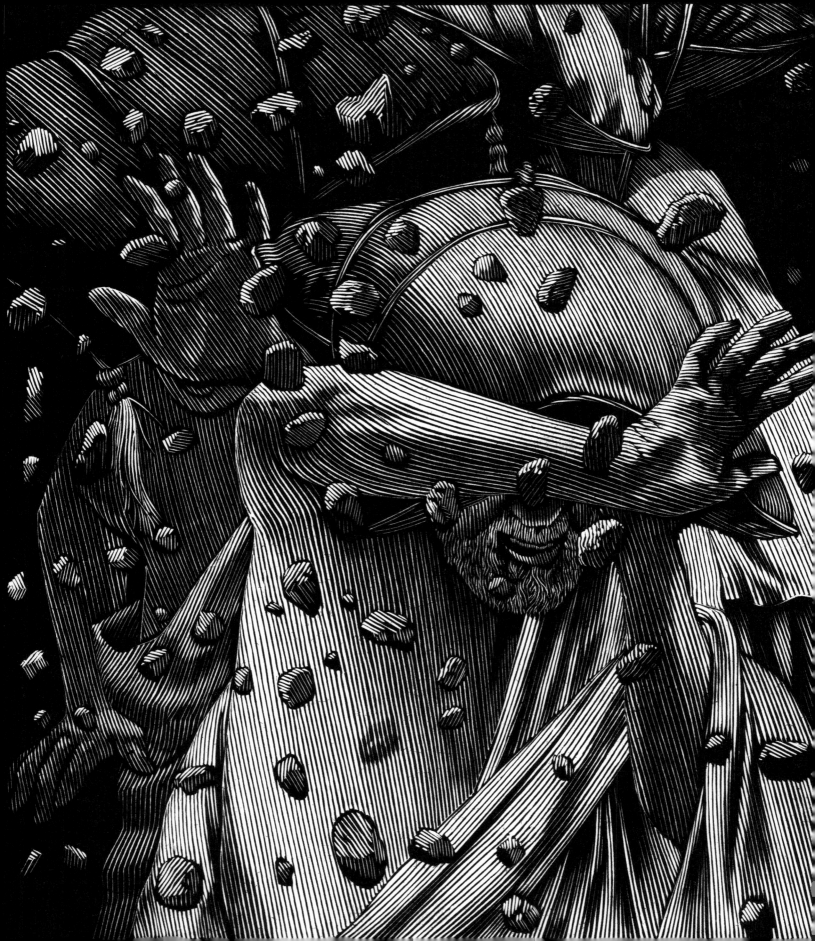

risk of falling pumice stones, even though they were light and porous, but this is what they opted for after comparing the dangers. In my uncle's case, he made his decision based on reason; for the others, fear was the determining factor. To protect themselves against falling objects, they tied pillows on their heads.

[17] By now it was day elsewhere [August 25], but where they were, it was the blackest and densest of nights, though it was broken up by many torches and various lights. They decided to go down to the shore and see from close up whether it was possible to set out to sea, but the sea was still rough and hostile. [18] There, lying on a sail spread out on the ground for him, he repeatedly demanded cold water and gulped it down. Then the flames and the smell of sulphur, which was a harbinger of the fires, made the others turn around and flee, and made my uncle get up. [19] Leaning on two slaves, he rose up and then immediately collapsed, because, I gather, his breathing was obstructed by the thick gases, and his naturally weak, narrow, and often inflamed throat was blocked. [20] When daylight returned [the morning of August 26] (on the third day after the last he had seen), his body was found, intact, uninjured, covered and dressed just as he had been: the appearance of his body looking more like someone asleep than dead.

[21] Meanwhile, at Misenum, my mother and I—but this has nothing to do with history, and you did not want me to write about anything other than my uncle's death. So I shall stop. [22] I shall add only one thing, namely, that I have described everything I witnessed myself or heard about immediately after the events, when things are most accurately remembered. You will select the most important things: for it is one thing to write a letter, another to write history; one thing to write to a friend, another to write to everyone.

Farewell.

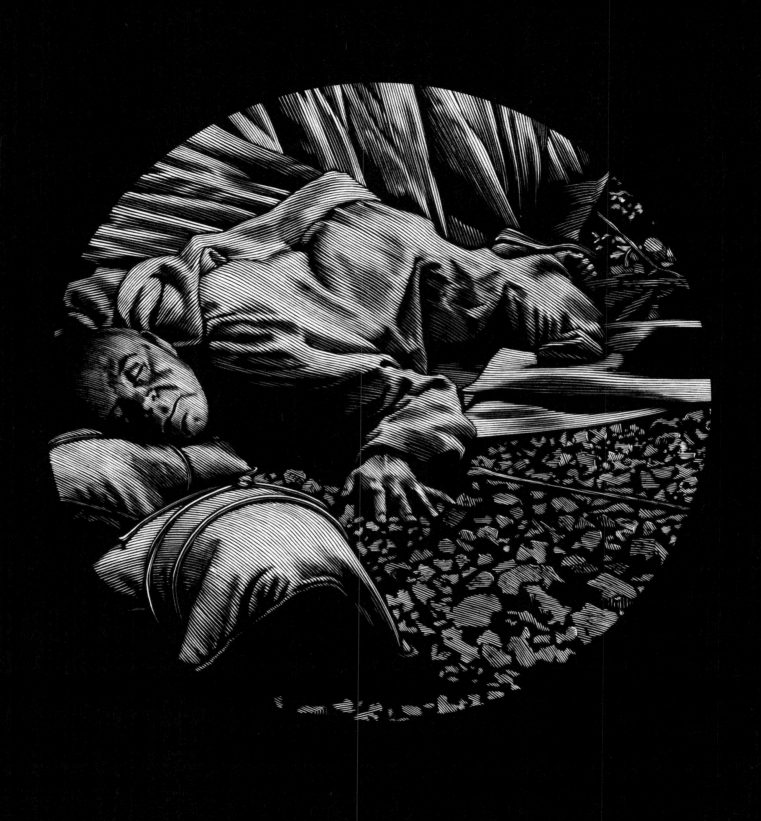

LETTER 6.20

Pliny greets his friend Tacitus.

You say that the letter I wrote, at your request, about the death of my uncle, made you wish to learn not only what fears but also what destruction I experienced when I was left behind at Misenum (for I began to write about that but broke off my account). "Though the mind shrinks from remembering . . . I shall begin." [Pliny here quotes Virgil's *Aeneid* 2.12–13, where Aeneas reluctantly begins to tell Dido about the Sack of Troy.]

[2] After my uncle departed, I spent the rest of the day on my studies (for this was the reason I stayed behind); then I had a bath, dinner, and a short, disturbed sleep. [3] For many days the earth had been shaking, which did not cause much fear, for earthquakes are common in Campania; but that night they became so strong that everything seemed not simply to move but rather to be turned upside down. [4] My mother rushed into my bedroom just as I myself was getting up to wake her if she were still asleep. We sat down in front of the part of the house closest to the sea; [5] I am not sure whether I should call it brave or foolish (I was seventeen at the time), but I asked for a book of Livy and read it as if for pleasure and even continued to write out the excerpts I had started on. Then came a friend of my uncle's, one who had recently come to visit him from Spain; when he saw my mother and me sitting there, and me even reading, he rebuked my

mother for putting up with me and me for my lack of concern. Nevertheless, I remained buried in my book.

[6] Now it was early morning [August 25], but the light was still faint and uncertain. Up until this point the surrounding buildings had been shaking, and, although we were in the open air, we were still in great and real danger from collapsing buildings, for it was a confined space. [7] At that time we finally decided to leave town. We were followed by a terrified crowd of people, who preferred someone else's resolve to their own (for fear may resemble prudence). In a mass movement they pressed forward and pushed us along. [8] Once we were clear of the houses, we stopped. There we experienced many astonishing and horrible things. For example, the carriages we had ordered brought out began to roll in different directions even though the ground was perfectly level, and they would not stay still even when they were wedged in their tracks with stones. [9] Then we saw the sea sucked out as if driven back by the upheavals of the earth. In any case, the shoreline had receded, and many sea creatures were left stranded on dry sand. From the other side, a terrifying pitch-black cloud, split open by quivering blasts of fire shooting in all directions, revealed long fiery shapes, similar to lightning flashes, only bigger. [10] Then that same friend from Spain spoke more shrilly and urgently. "If your brother and your uncle lives, he wants you to be safe; if he has died, he wanted you to survive. So why do you do nothing to escape?" We replied that we could not begin to think about our own safety as long as we were uncertain about his. [11] Without any further delay, he rushed off, running away from the danger. Not long after that, the cloud sank down over the land and concealed the sea; it had already surrounded and concealed Capri and the promontory of Misenum. [12] Then

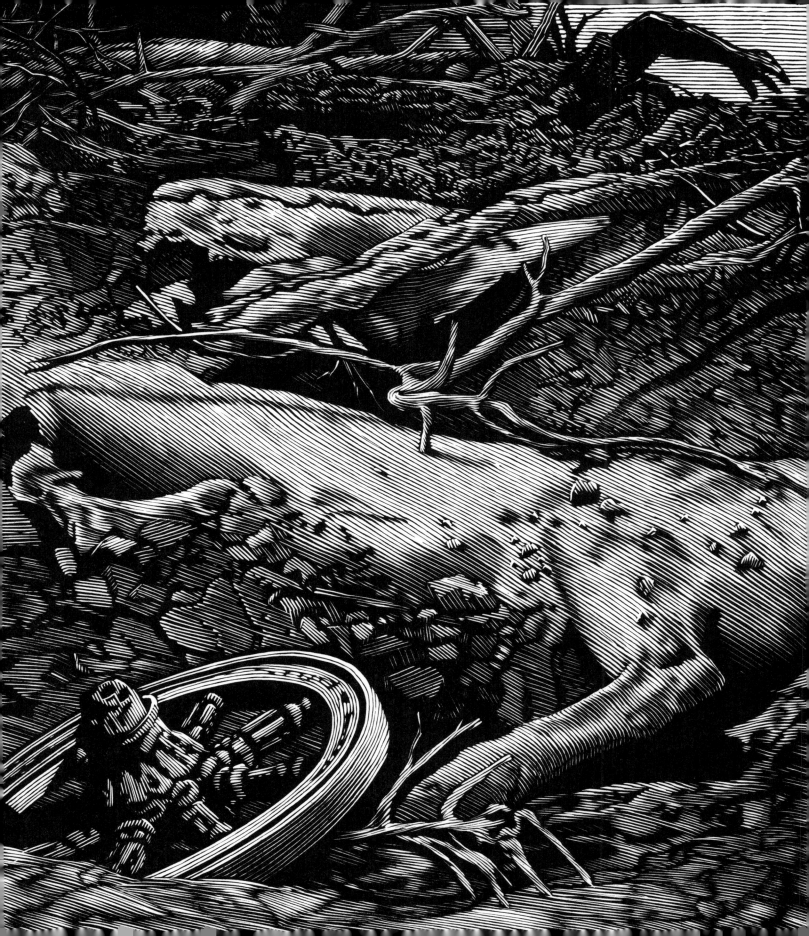

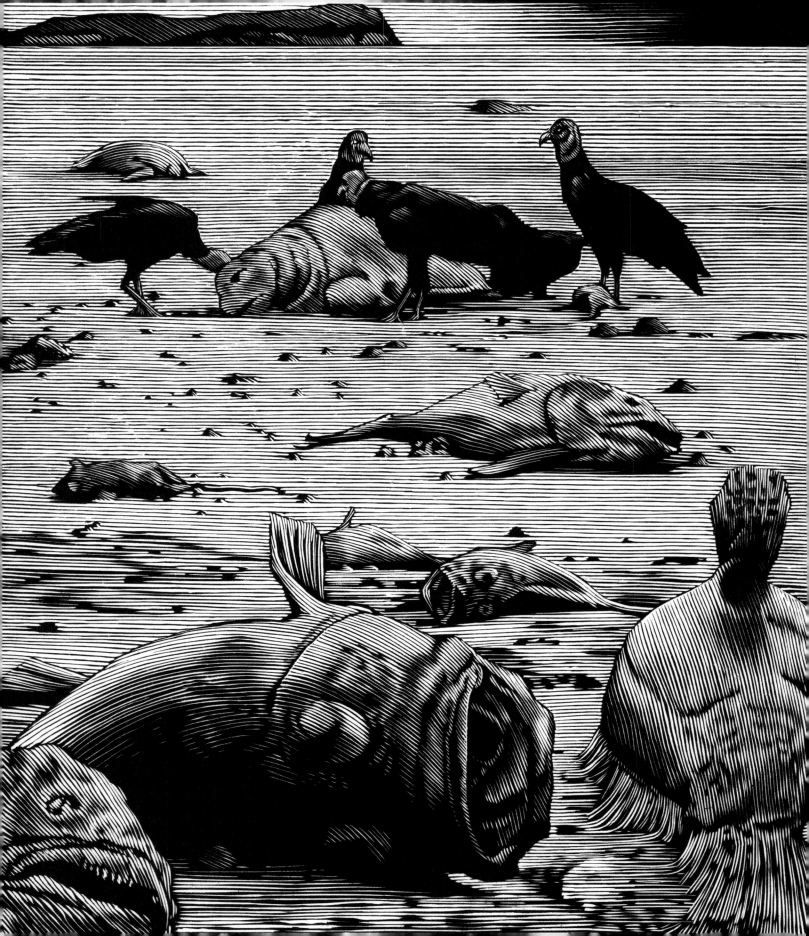

my mother beseeched, encouraged, and ordered me to escape by whatever means I could; as a young man I could do so, but she, being both old and weighed down, could be satisfied to die as long as she were not the cause of my death. I told her I would not save myself without her; then, taking her hand in mine, I forced her to take a step. She complied with difficulty and blamed herself for delaying me.

[13] Ash was now falling, although not yet thickly. I looked back: dense blackness loomed behind us, pursuing us like a torrent poured out over the earth. "Let us leave the road while we can still see," I said, "so that we won't be knocked down and crushed in the darkness by the crowd around us." [14] We had only just sat down when darkness fell, a darkness not like a moonless or cloudy night but like a closed room when the light is extinguished. You could hear the howls of women, the wailing of babies, and the shouts of men: some were calling for their parents, some for their children, some for their spouses, trying to recognize their voices; some lamented their own misfortune, others that of their relatives; there were some who in their fear of dying begged for death; [15] many raised their hands to the gods; still more concluded that there were no gods left and that harsh and everlasting night had descended on the world. And there were those who added to the real danger by inventing fictitious terrors. Some spread the news that one part of Misenum had collapsed and another part was burning: though this was not true, people believed it. [16] A little light returned, but it seemed to us a sign, not that day was coming, but that the fire was close by. Yet the fire actually remained some way off; darkness returned, and ash started falling heavily. Again and again we got up to shake off the ash, otherwise we would have been covered and even crushed by the weight. [17] I could boast that

33

< SEA CREATURES WERE LEFT STRANDED

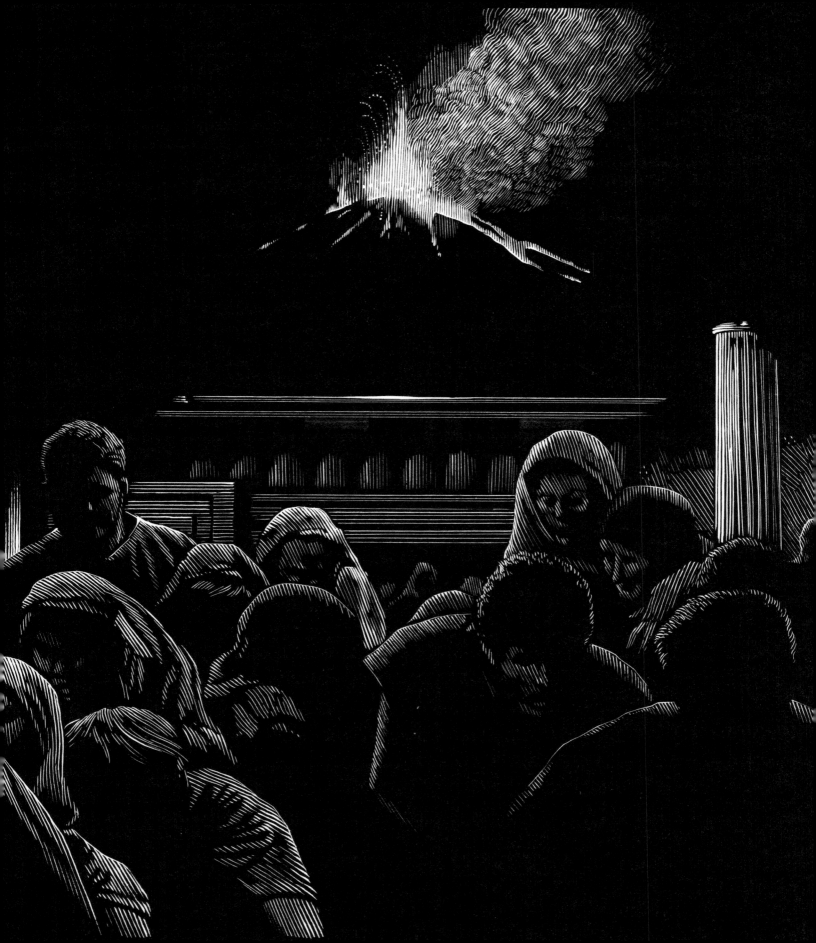

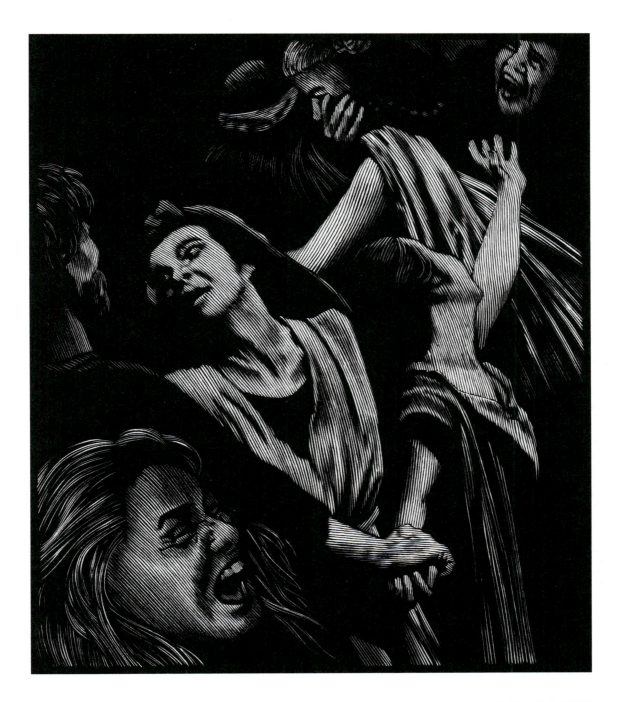

SOME BEGGED FOR DEATH

< DENSE BLACKNESS LOOMED BEHIND US

no groan or feeble cry escaped my lips, but in truth in all these dangers I found considerable and pitiable consolation in the belief that I was perishing along with everyone else and everything was perishing with me.

[18] At last the darkness diminished and dissipated like smoke or a cloud; presently there was true daylight; the sun even shone, though feebly, as during an eclipse. Our frightened eyes beheld a changed world— all around us everything was covered by deep ash, as if it were snow. [19] We returned to Misenum, where we took care of our physical needs as best we could and spent an anxious night [of August 25–26], wavering between hope and fear. Fear predominated, for the earthquakes continued, and many frantic people, thanks to their terrifying prophesies, made their own fear and that of others seem ridiculous. [20] Nevertheless, despite both the danger we had lived through and what we expected was still in store for us, not even then did we have any plan to leave before we had news of my uncle.

These matters are of no consequence for history, and you will read about them without any intention of writing about them. If these things seem not worthy even of a letter, you know that you have only yourself to blame for asking me to write about them.

Farewell.

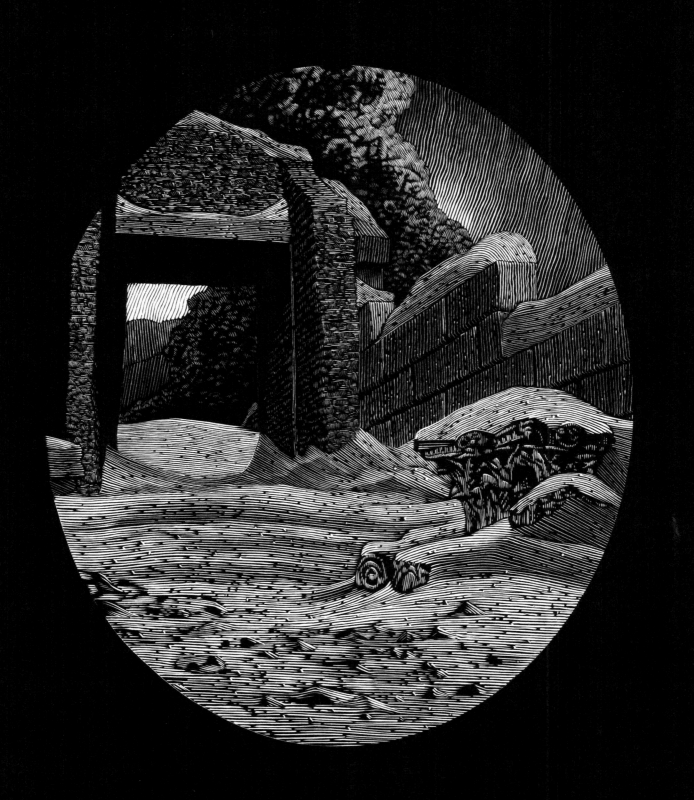

Suggestions for Further Reading

Johnson, Dora. "The Manuscripts of Pliny's Letters." *Classical Philology* 7 (1912): 66–75.

Pliny the Elder. *Natural History*. English and Latin. 10 vols. Translated by H. Rackham. Loeb Classical Library. Cambridge, MA, 1980.

Pliny [the Younger]. *Letters and Panegyricus*. English and Latin. Vol. 1. Translated by Betty Radice. Loeb Classical Library. Cambridge, MA, 1972.

Pliny the Younger. *The Letters of the Younger Pliny*. Translated by Betty Radice. Penguin Classics, Harmondsworth, Eng., 1969.

Reynolds, L. D., ed. *Texts and Transmission: A Survey of the Latin Classics*, p. 316–22. Oxford, 1983.

Sherwin-White, A. N. *The Letters of Pliny: A Historical and Social Commentary*. Oxford, 1985.

Sigurdsson, Haraldur, et al. "The Eruption of Vesuvius in A.D. 79: Reconstruction from Historical and Volcanological Evidence." *American Journal of Archaeology* 86 (1982): 39–51.

Sigurdsson, Haraldur, and Steven Carey. "The Eruption of Vesuvius in A.D. 79." In *The Natural History of Pompeii*, ed. Wilhelmina Feemster Jashemski and Frederick G. Meyer, pp. 37–64. Cambridge, 2002.

Tacitus. *The Annals of Imperial Rome*. Translated by Michael Grant. Penguin Classics. Harmondsworth, Eng., 1977.

Tacitus. *The Complete Works of Tacitus*. Translated by Alfred John Church and William Jackson Brodribb. New York, 1942.

Tacitus. *Works*. English and Latin. 5 vols. Various translations. Loeb Classical Library. Cambridge, MA, 1970–81.

About the Artist and His Work

Wood engraving was invented in the late eighteenth century. The wood of choice is boxwood, cut on the end grain; lemon, holly, pear, and maple are other good choices. Because these woods have all become scarce and very expensive, Barry Moser now uses a cast polymer resin called Resingrave™, a flintlike synthetic that engraves like the finest boxwood. Although he works in the classic manner of a wood engraver, he has coined the phrase "relief engraving" to describe his work.

The very precise blocks—whether wood or Resingrave™—are produced at the universal "type high" measure—.918 inch—which allows the blocks to be locked up and printed with the type. Moser composes his image on a computer and then transfers it to the engraving block. There he completely redraws the image, engraves it, and prints the block on a printing press. For a limited-edition book, the images are printed alongside the typography directly from the block. For a book such as *Ashen Sky,* Moser scans the engraved blocks at a very high resolution, cleans up any scratches or broken lines, and sends the scans to the printer.

Since 1970 Barry Moser has provided wood engravings for more than a hundred books, including editions of *Moby Dick*, *Alice's Adventures in Wonderland*, and a King James Version of the Bible. His works are found in museums throughout the world as well as in rare book rooms and special collections of libraries.

Currently Professor in Residence in the Art Department of Smith College, Barry Moser lives in western Massachusetts with his wife, two English mastiffs, and four cats.

David Sider, Consultant, *Latin translations*

Sahar Tchaitchian and Tobi Kaplan, *Copy editors*

Kurt Hauser, *Designer*

Elizabeth Zozom, *Production coordinator*

Library of Congress Cataloging-in-Publication Data

Moser, Barry.

 Ashen sky : the letters of Pliny the Younger on the eruption of Vesuvius / woodblock illustrations by Barry Moser.

 p. cm.

 Includes Pliny's Letters 6.16 and 6.20, translated from Latin.

 ISBN 978-0-89236-900-3 (hardcover)

 1. Moser, Barry. 2. Vesuvius (Italy)—In art. 3. Vesuvius (Italy)—Eruption, 79. I. Pliny, the Younger. Epistularum libri VI.

English. Selections. II. Title.

 NE1112.M67A4 2007

 769.92–dc22

 2007002781

Printed in Singapore by Tien Wah Press

Text paper is Senlis. It contains wood from well-managed forests certified in accordance with the sustainable practices of the PEFC (Programme for the Endorsement of Forest Certification).

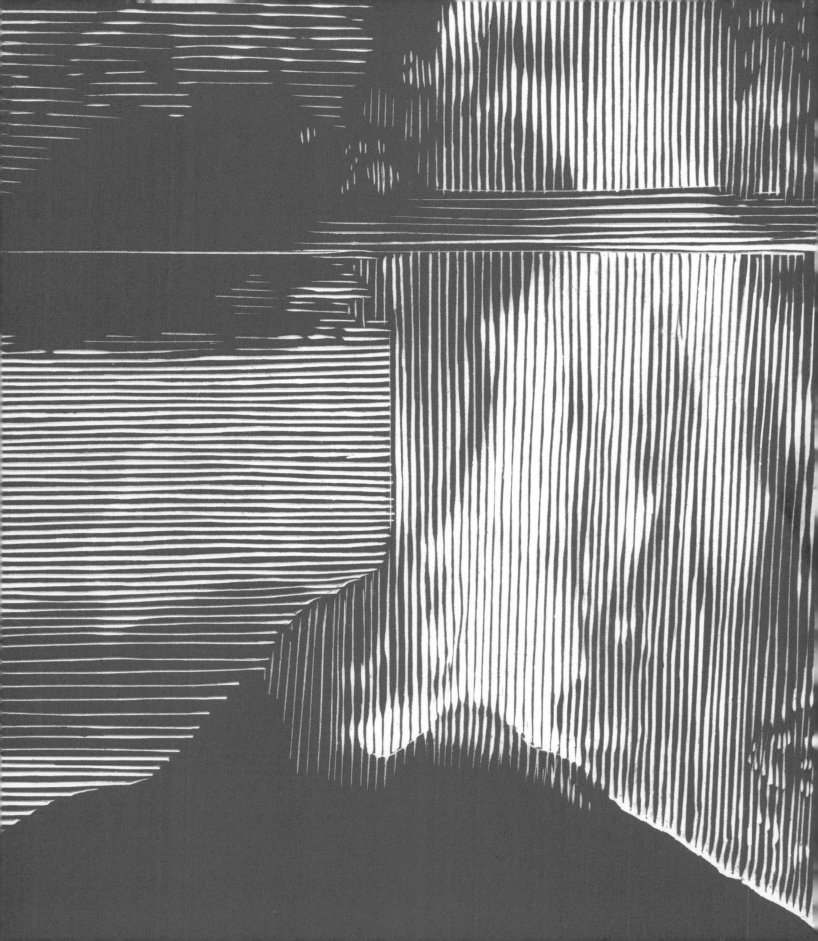